EVERY PAGE HAS A CHALLENGE

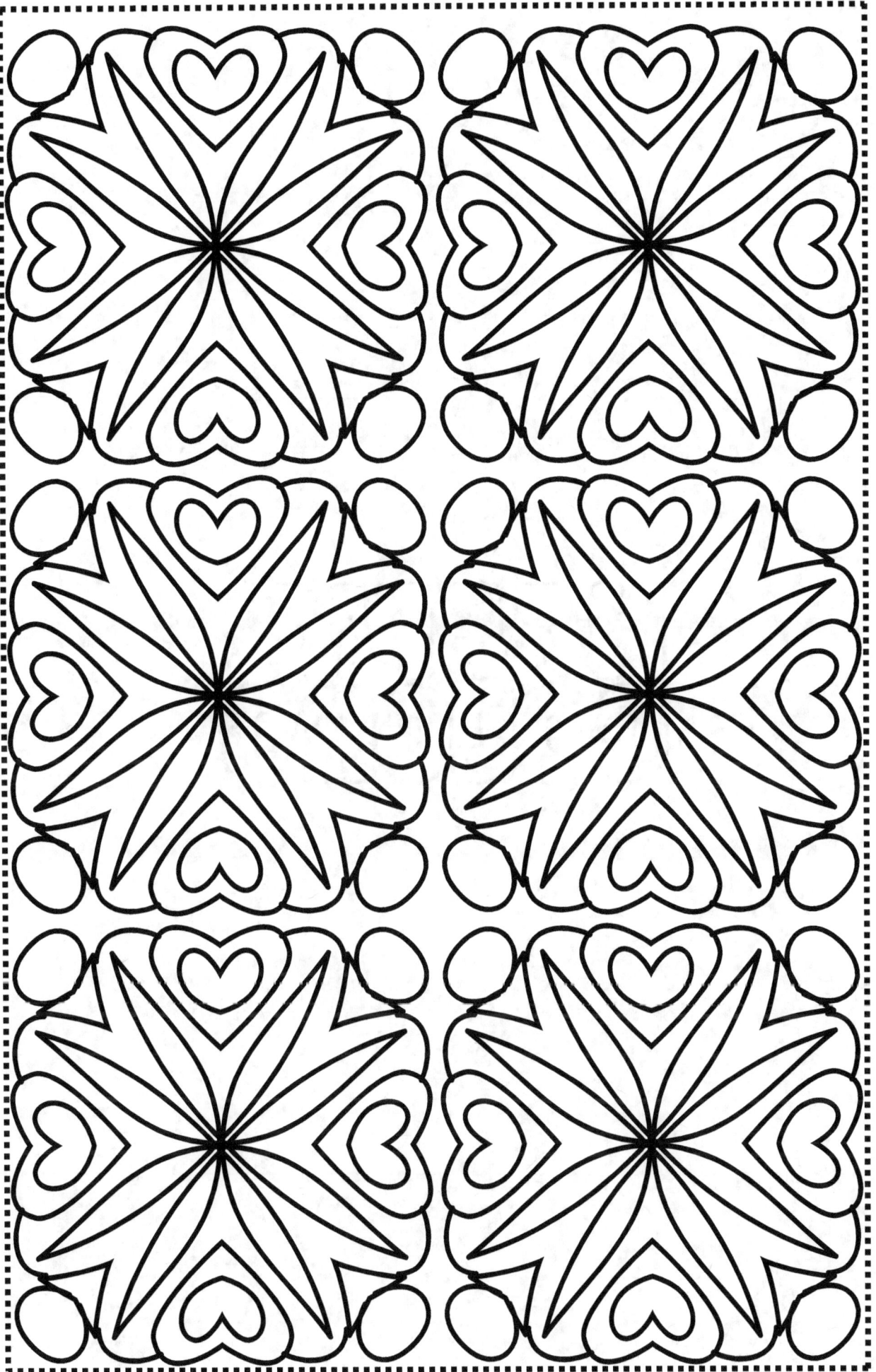

I AM SPRING

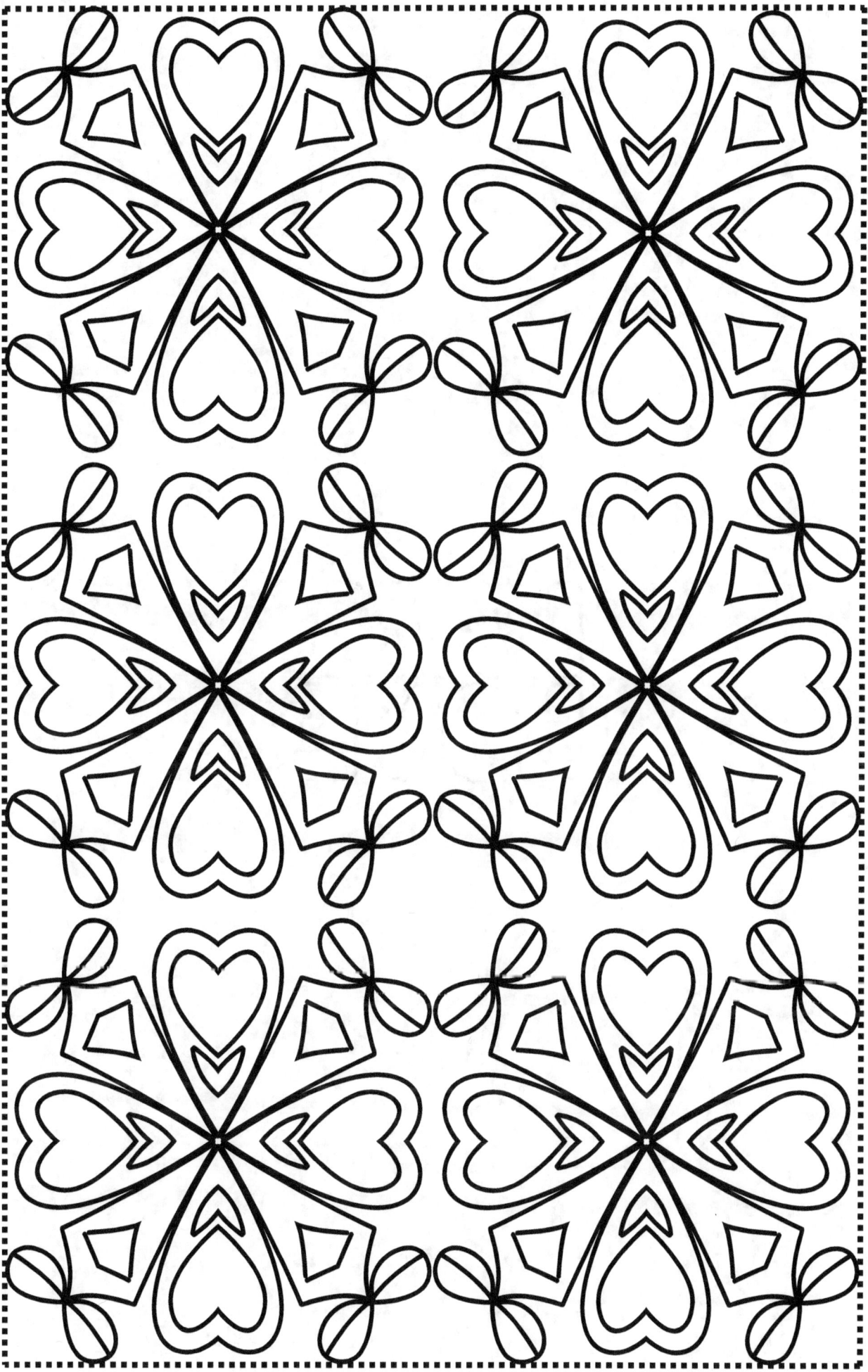

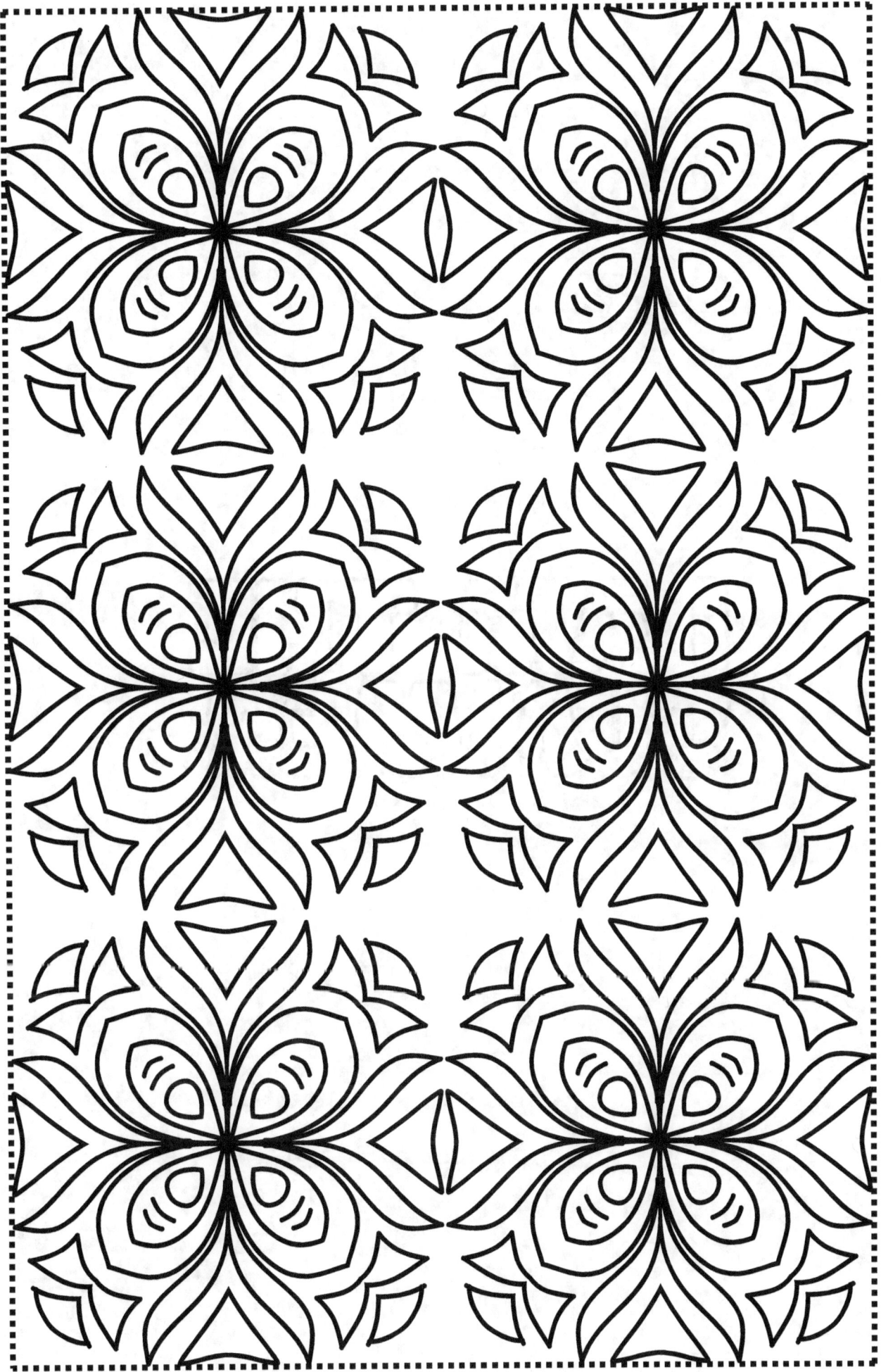

I AM THE SUMMER

I'M ALIVE

I'M A ZOMBIE

SEABED

SKY

FOREST

HALLOWEEN

WEEKEND

FLOWERS

PLANETS

SHADES OF PURPLE AND GREEN

www.ingramcontent.com/pod-product-compliance
Lightning Source LLC
Chambersburg PA
CBHW062315220526
45479CB00004B/1180